Snake Adult Coloring Book

This Snake Coloring book belongs to:

Copyright © 2019 Adult Coloring Books

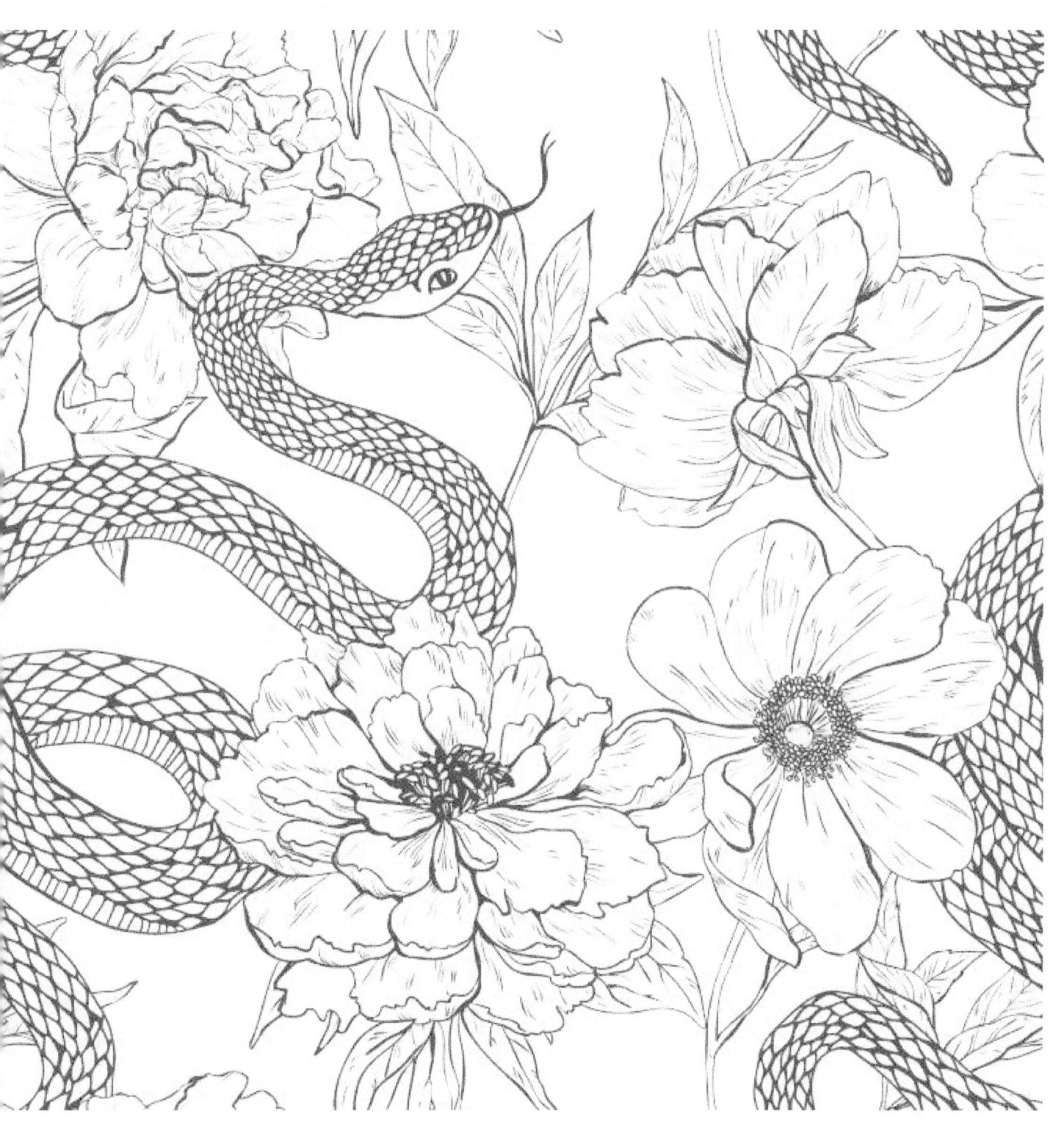

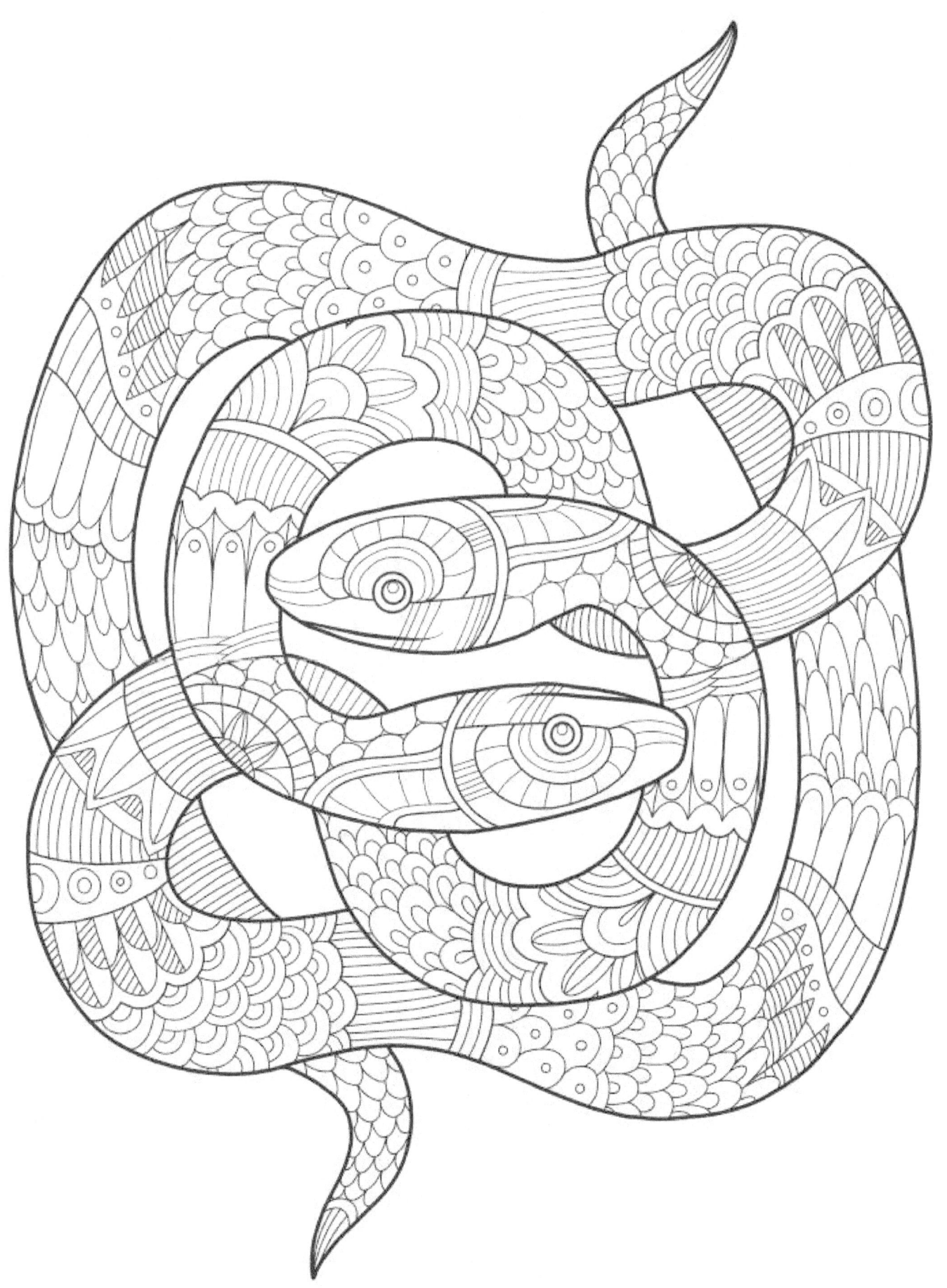

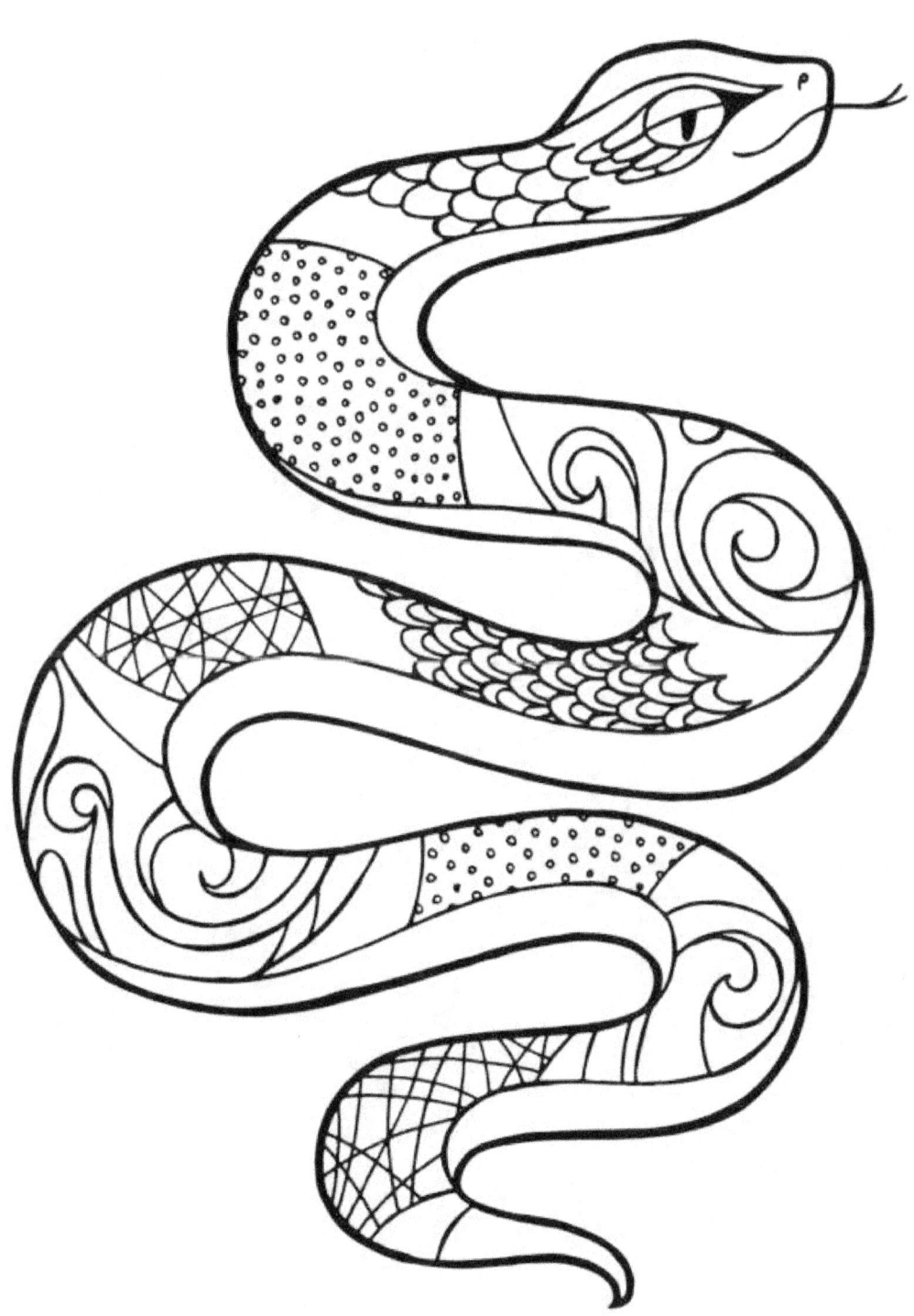

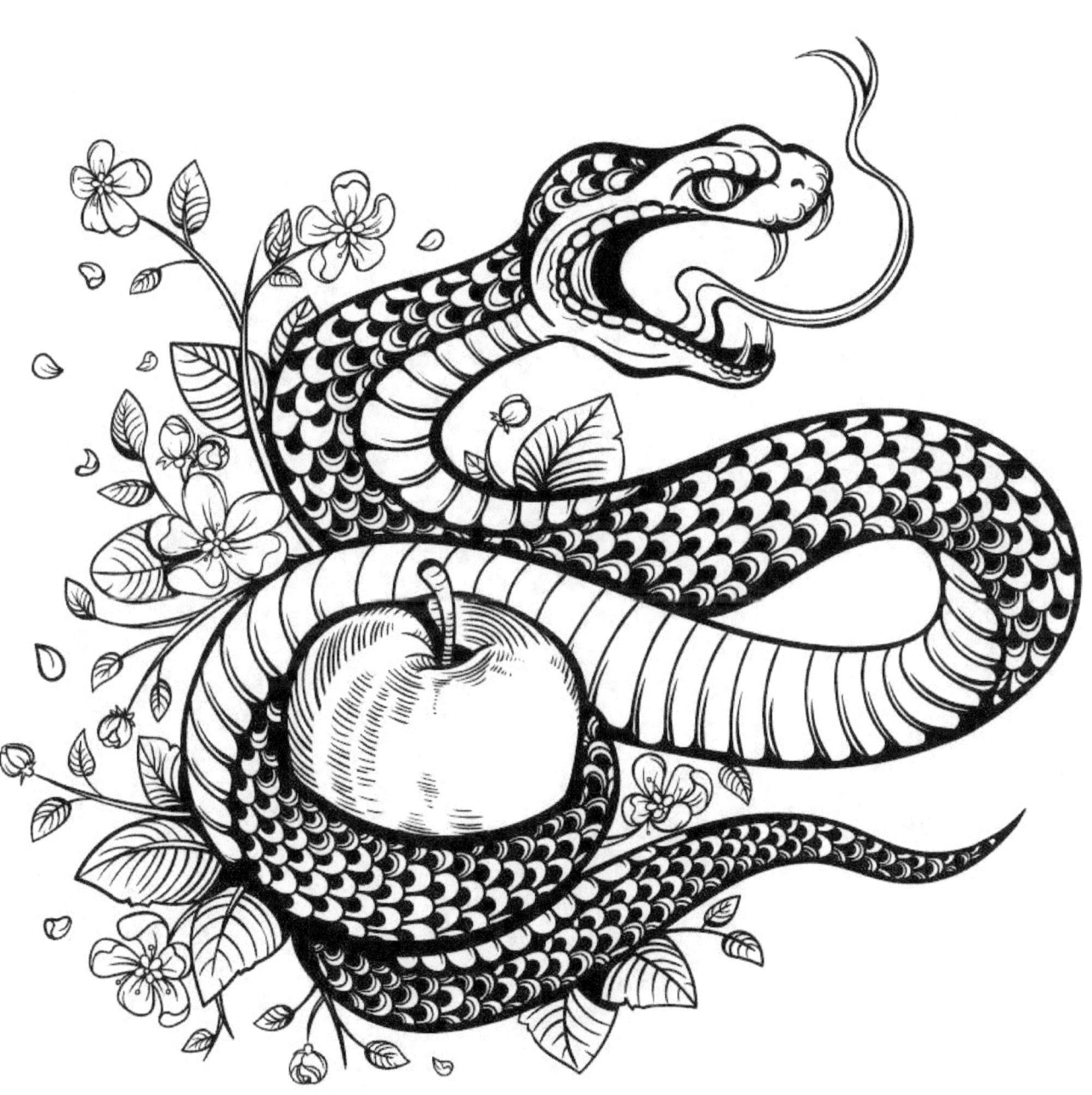

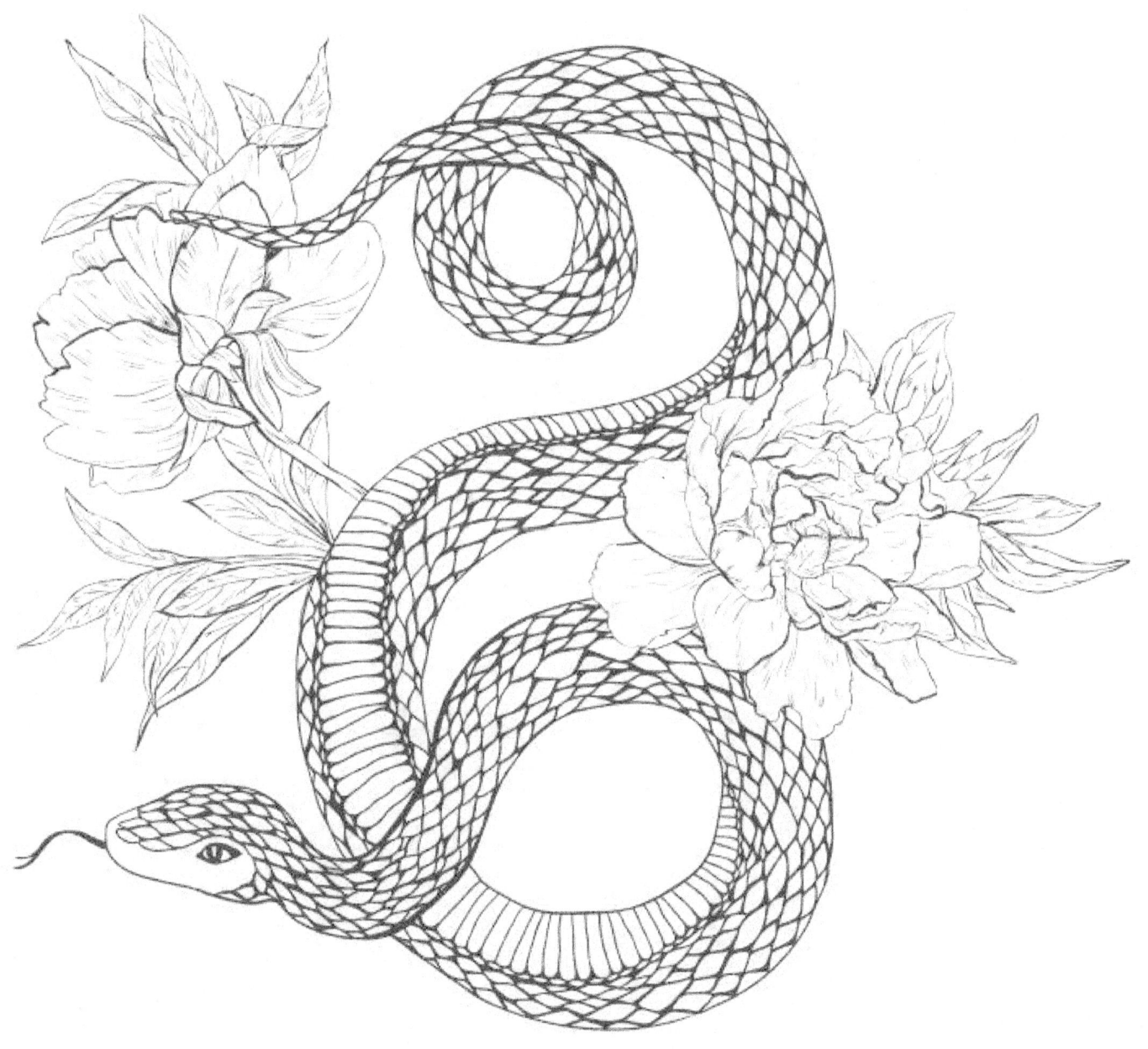

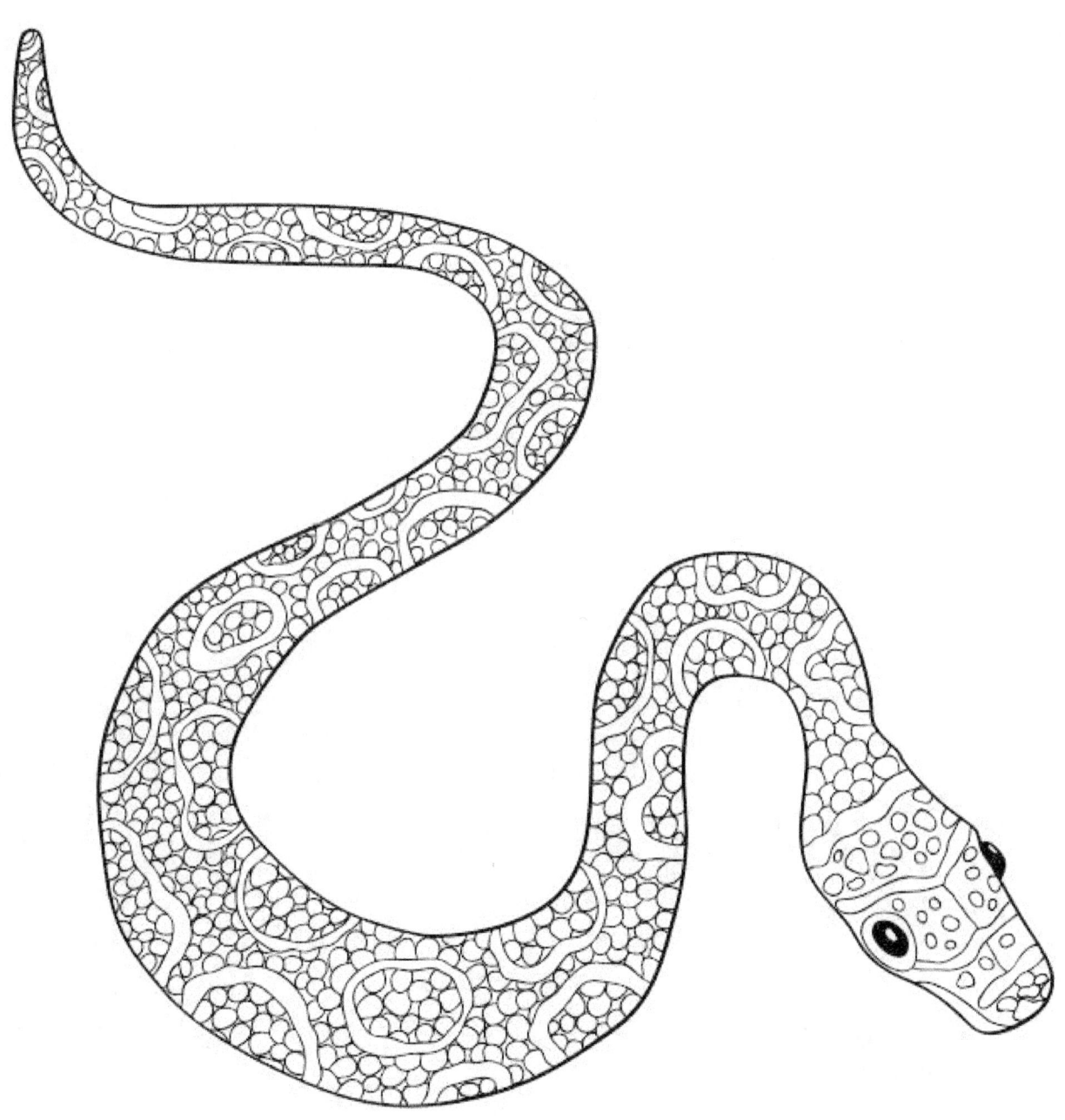

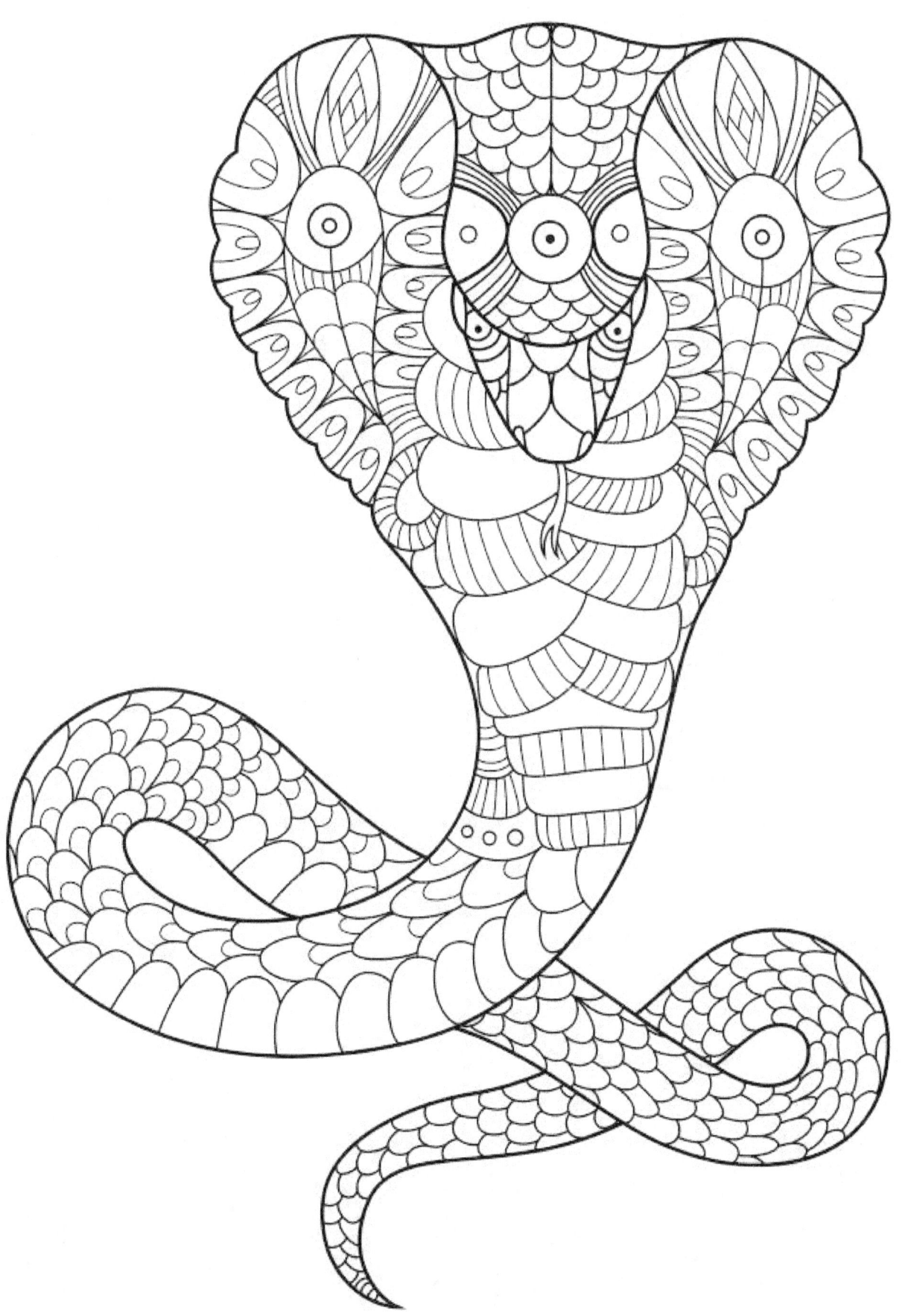

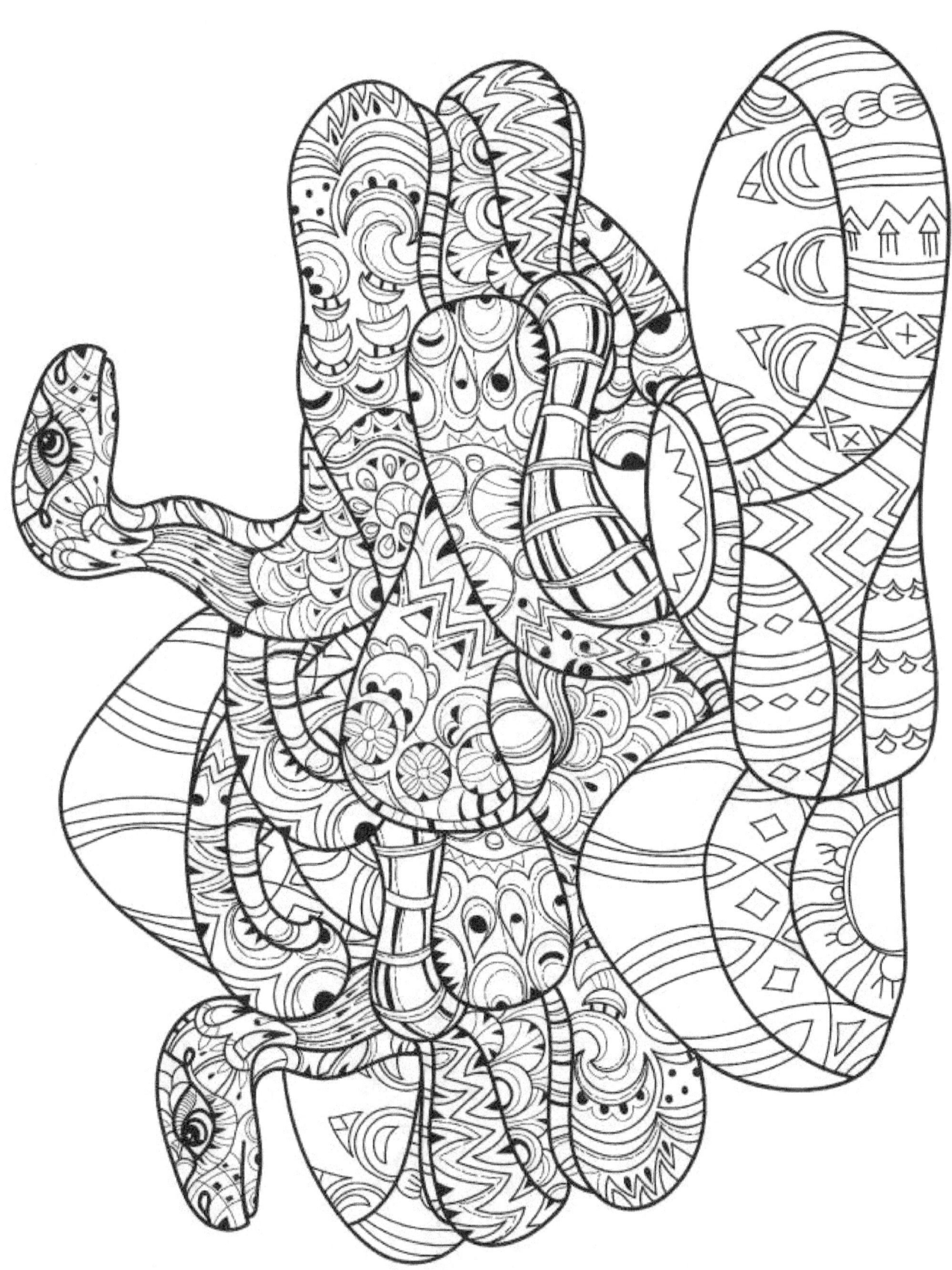

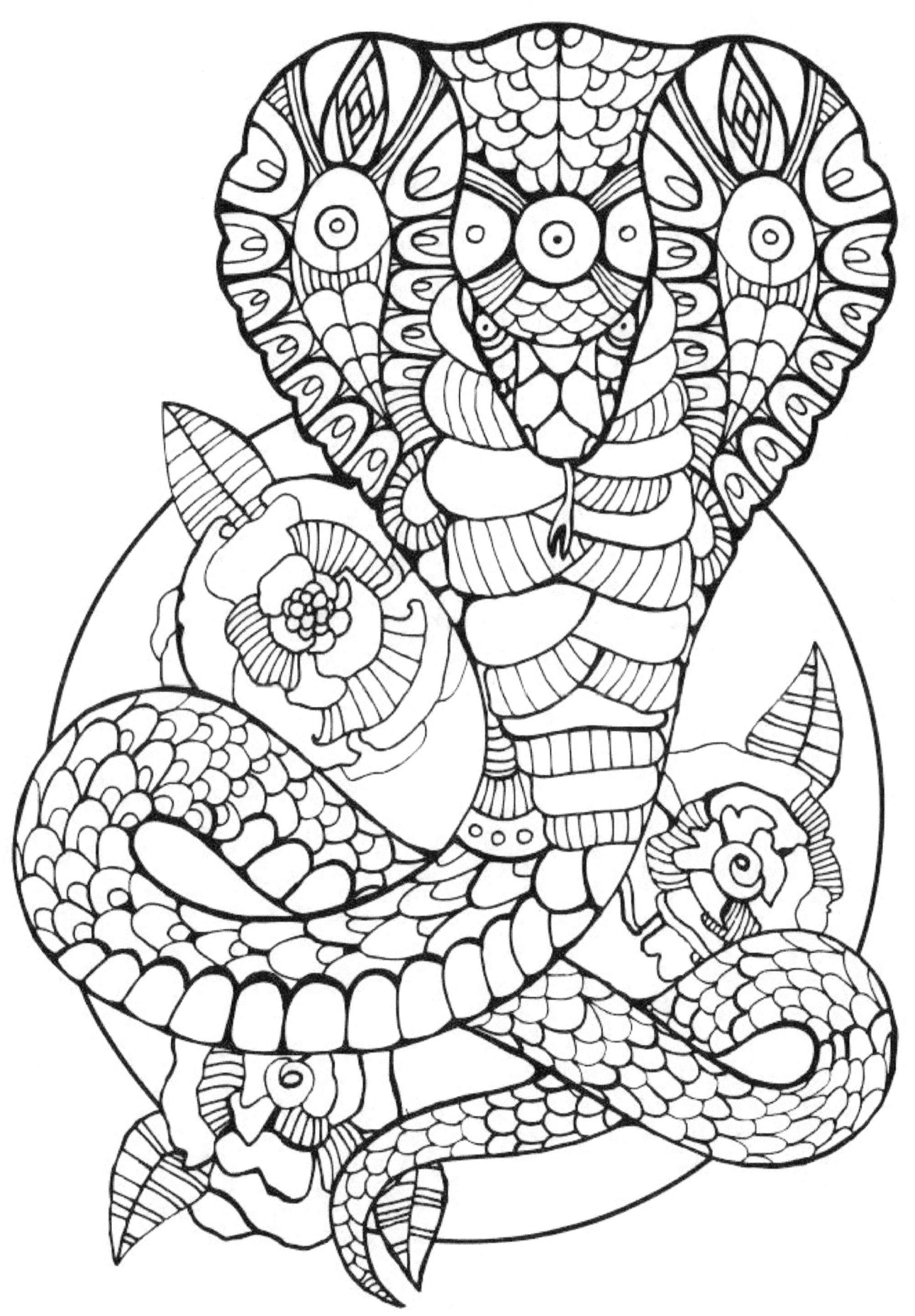

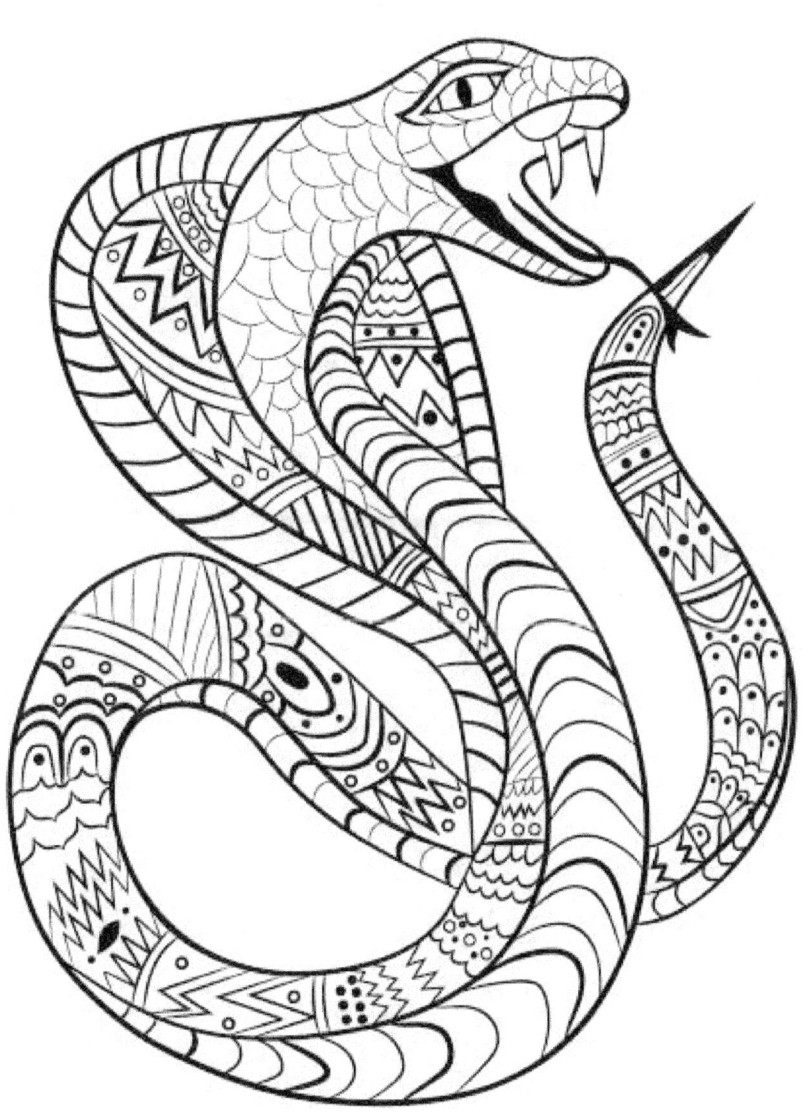

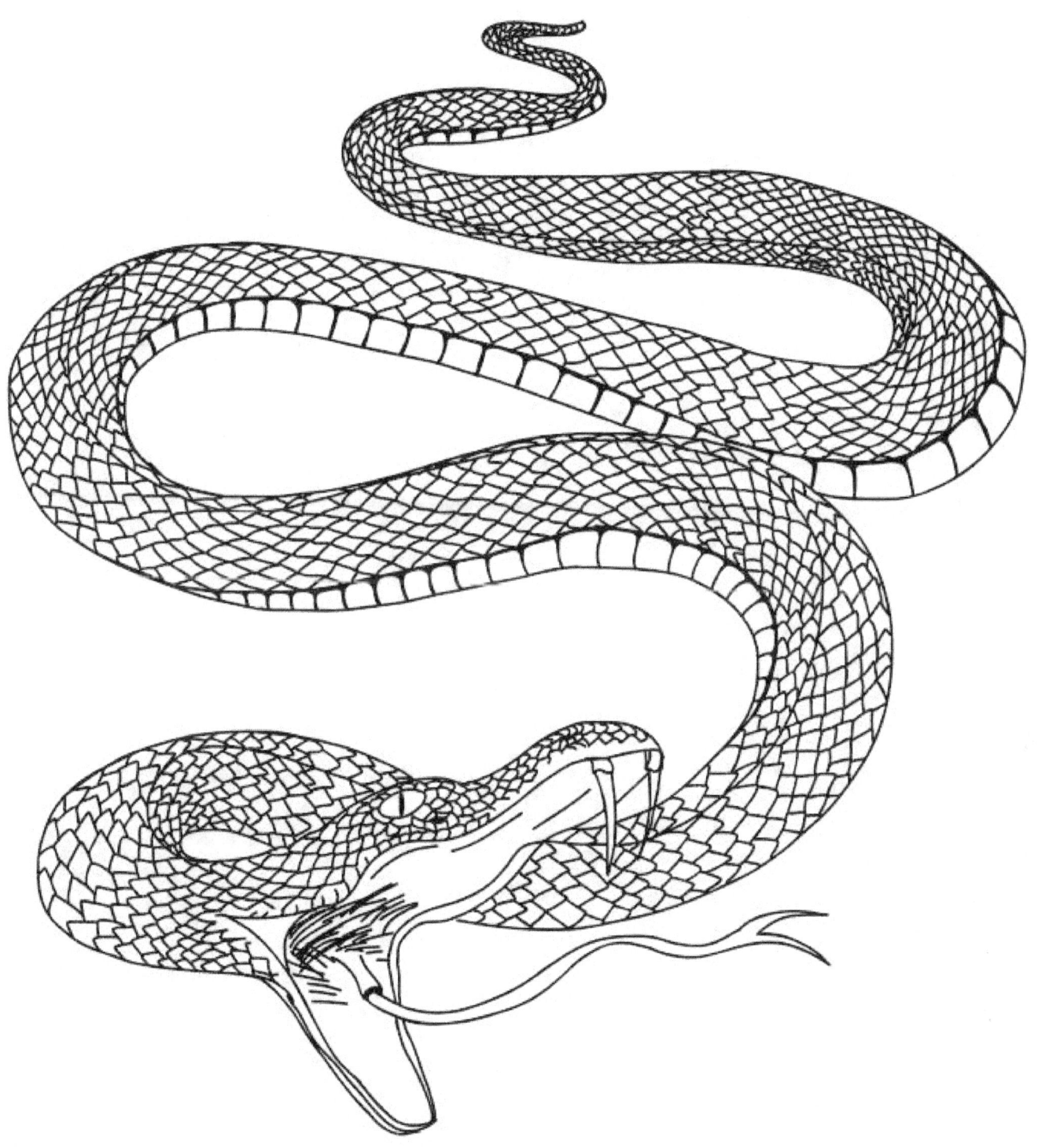

Bonus Sea Turtles Coloring Pages

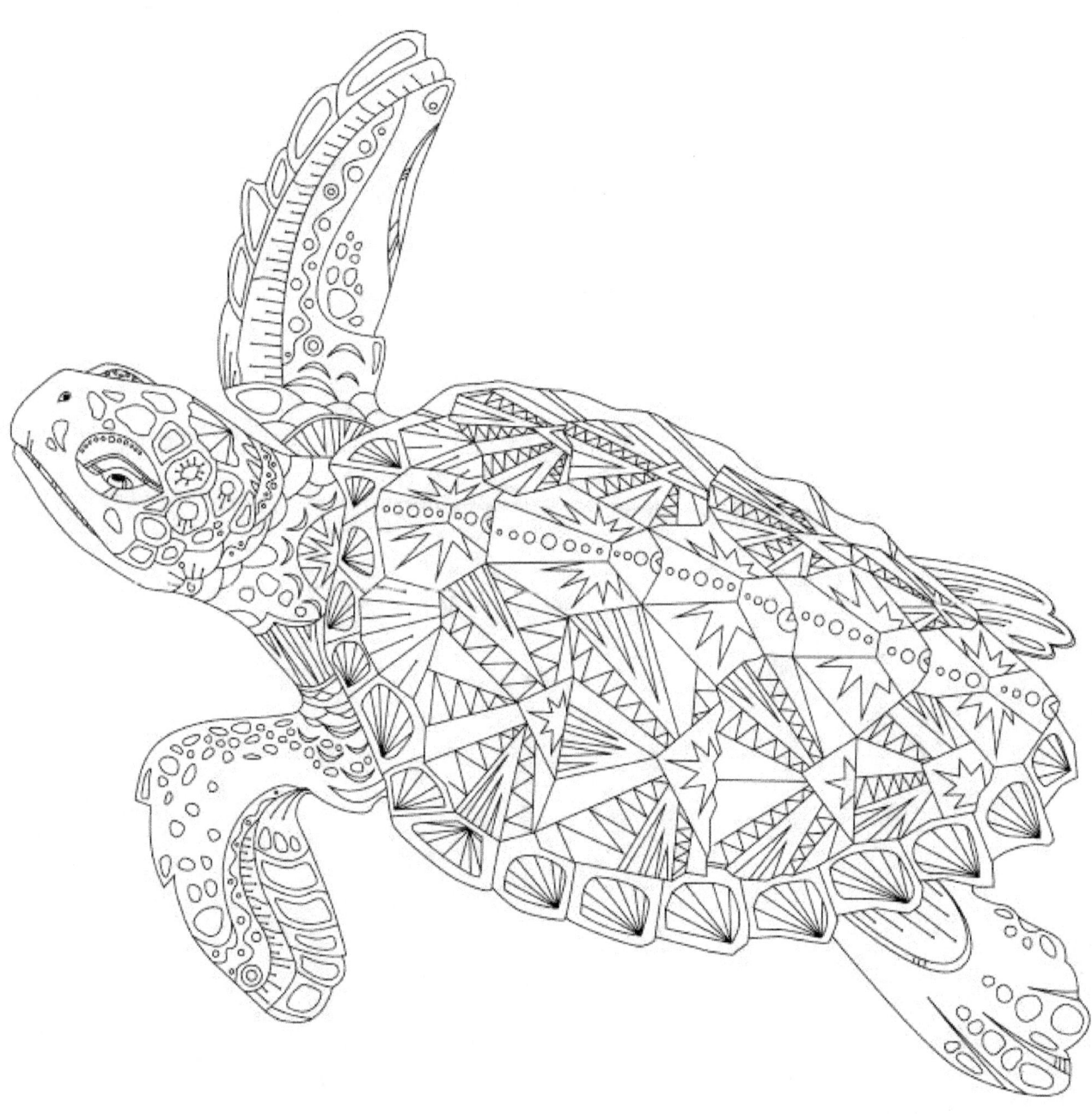

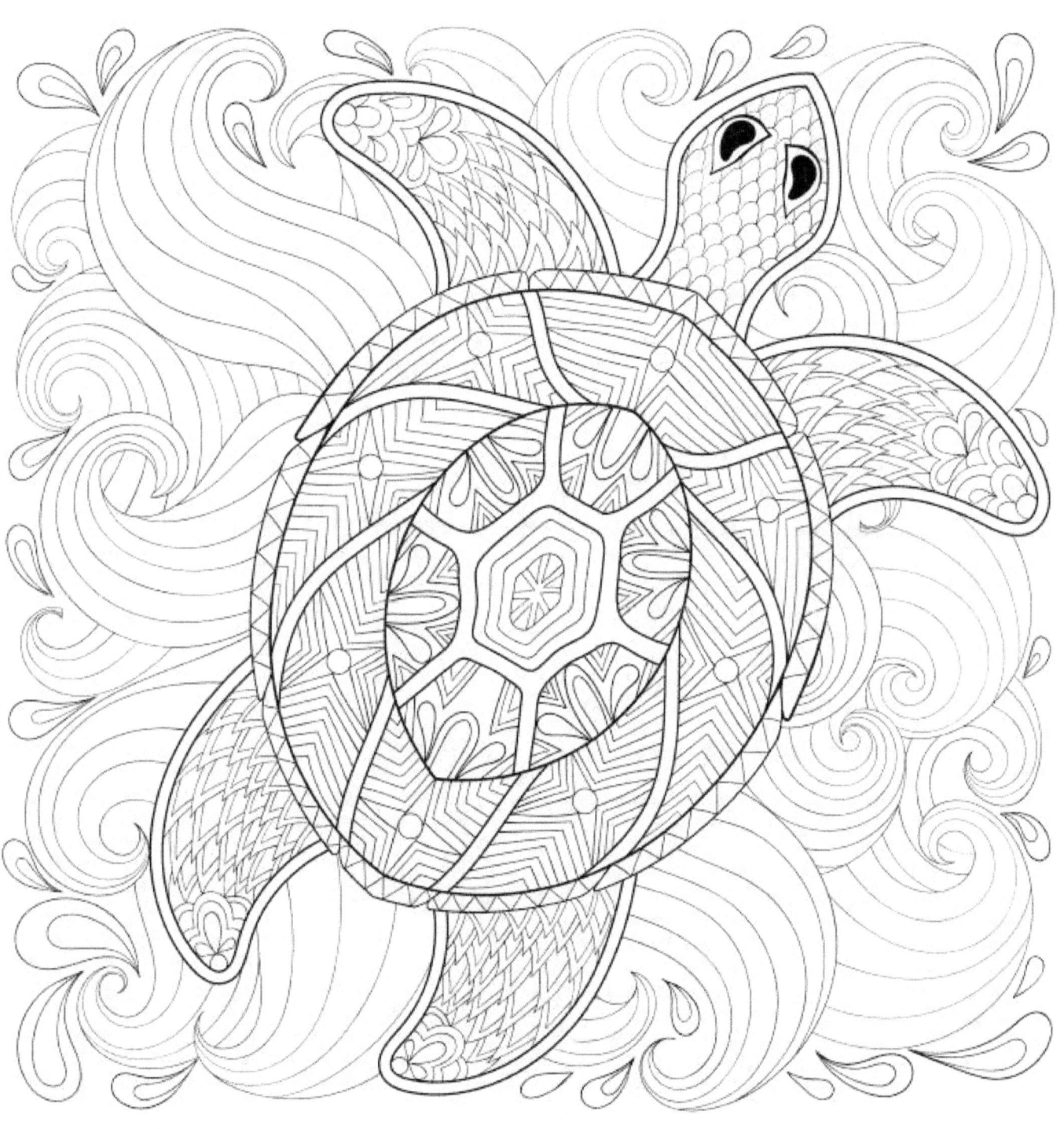

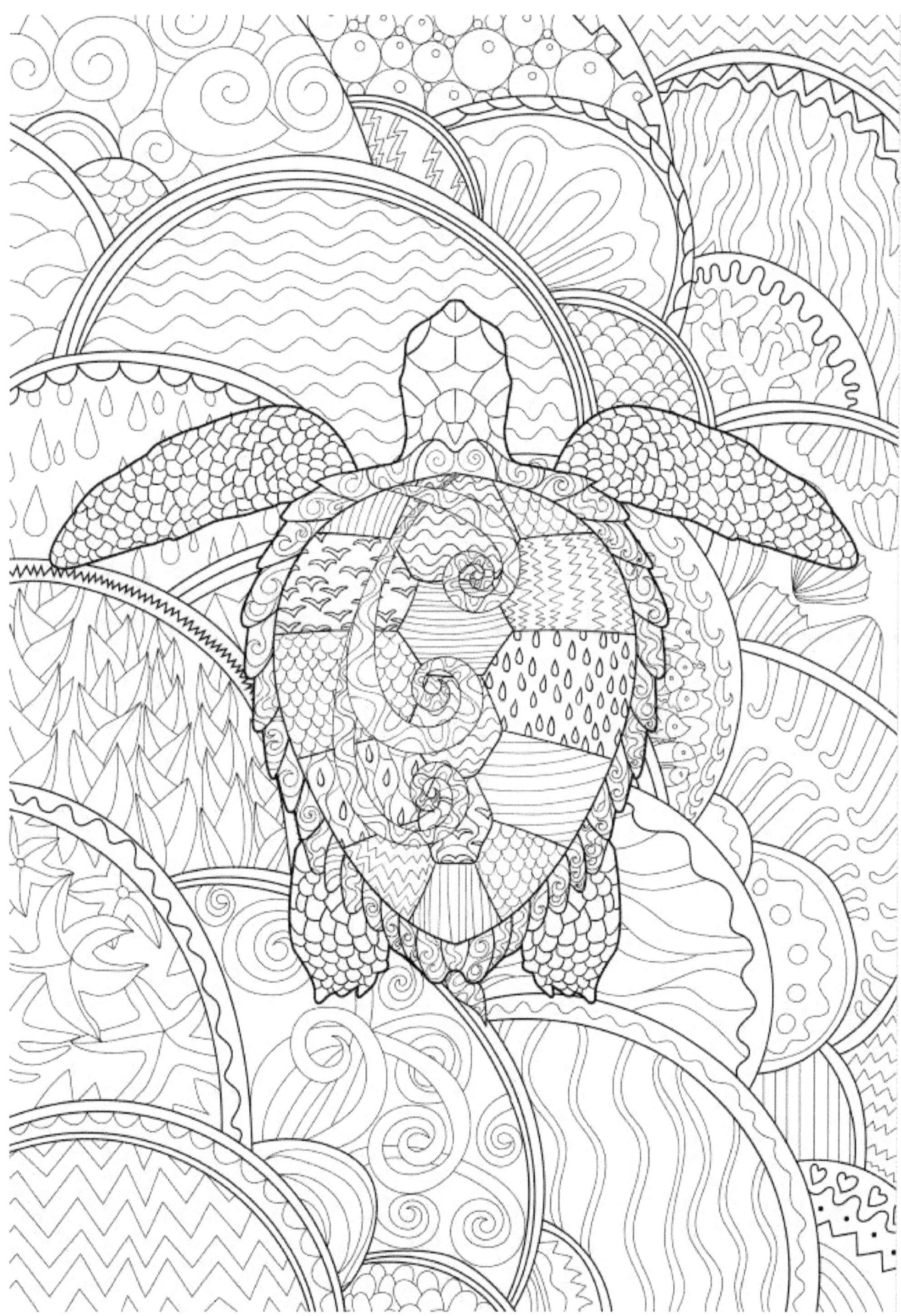

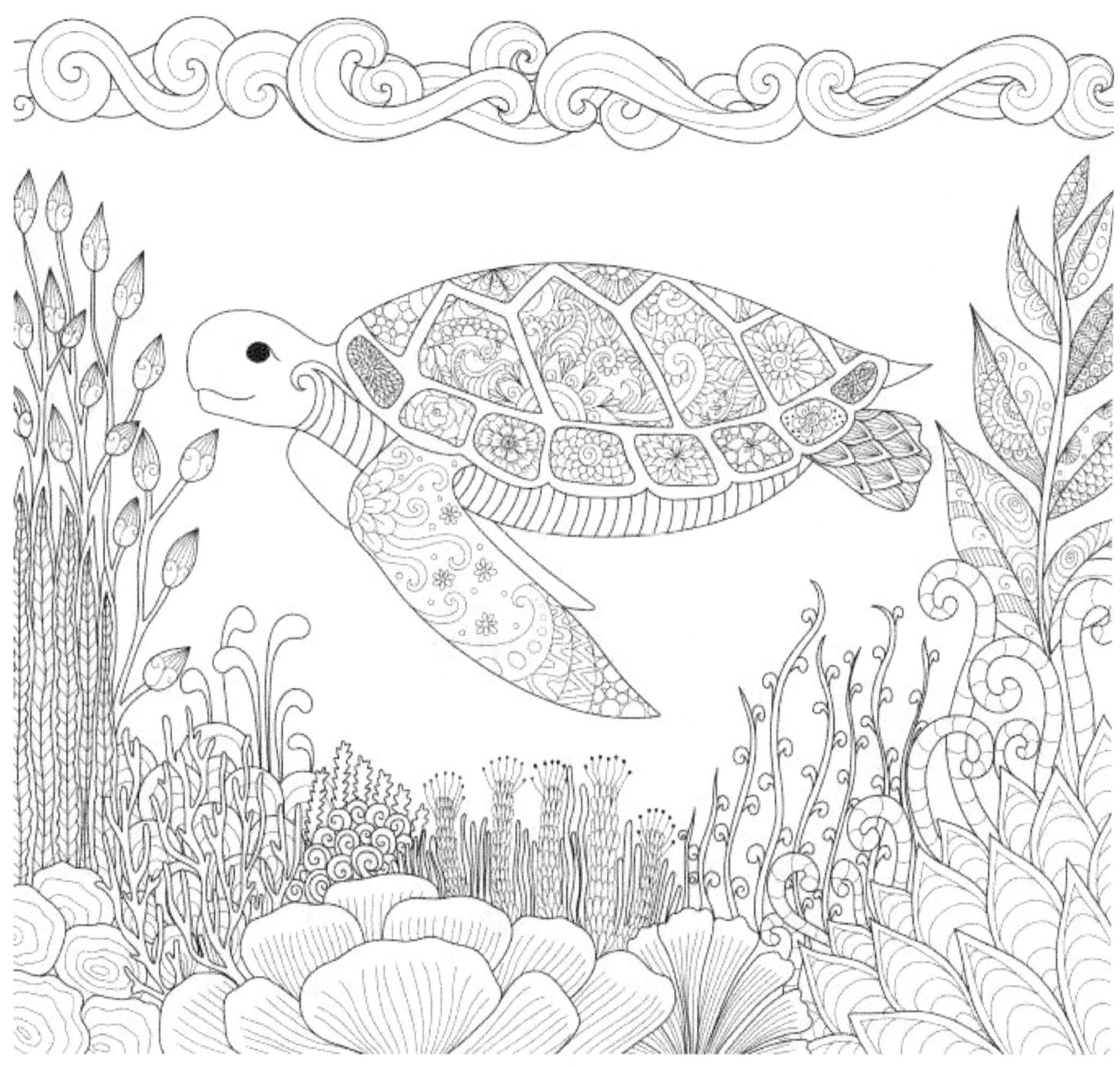

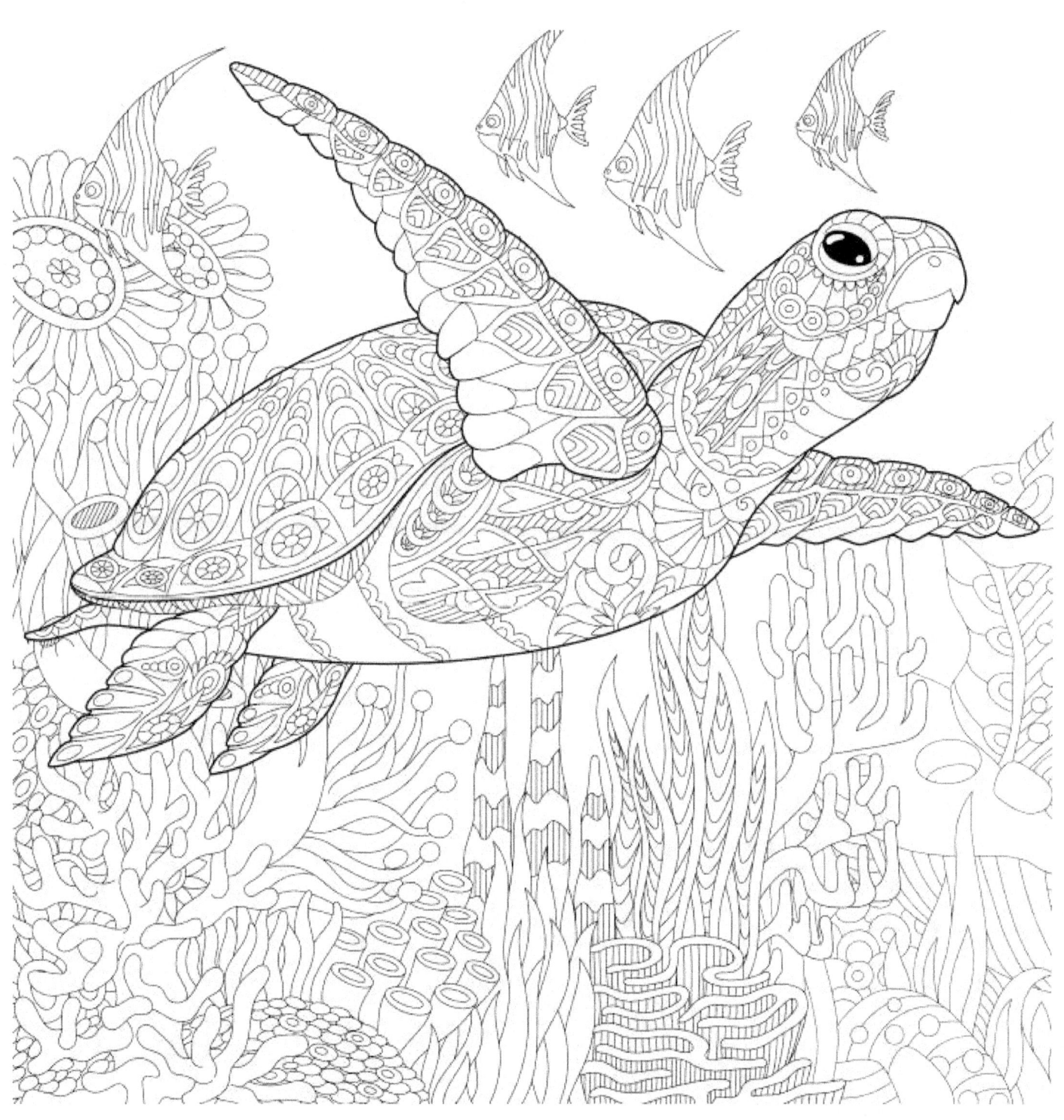

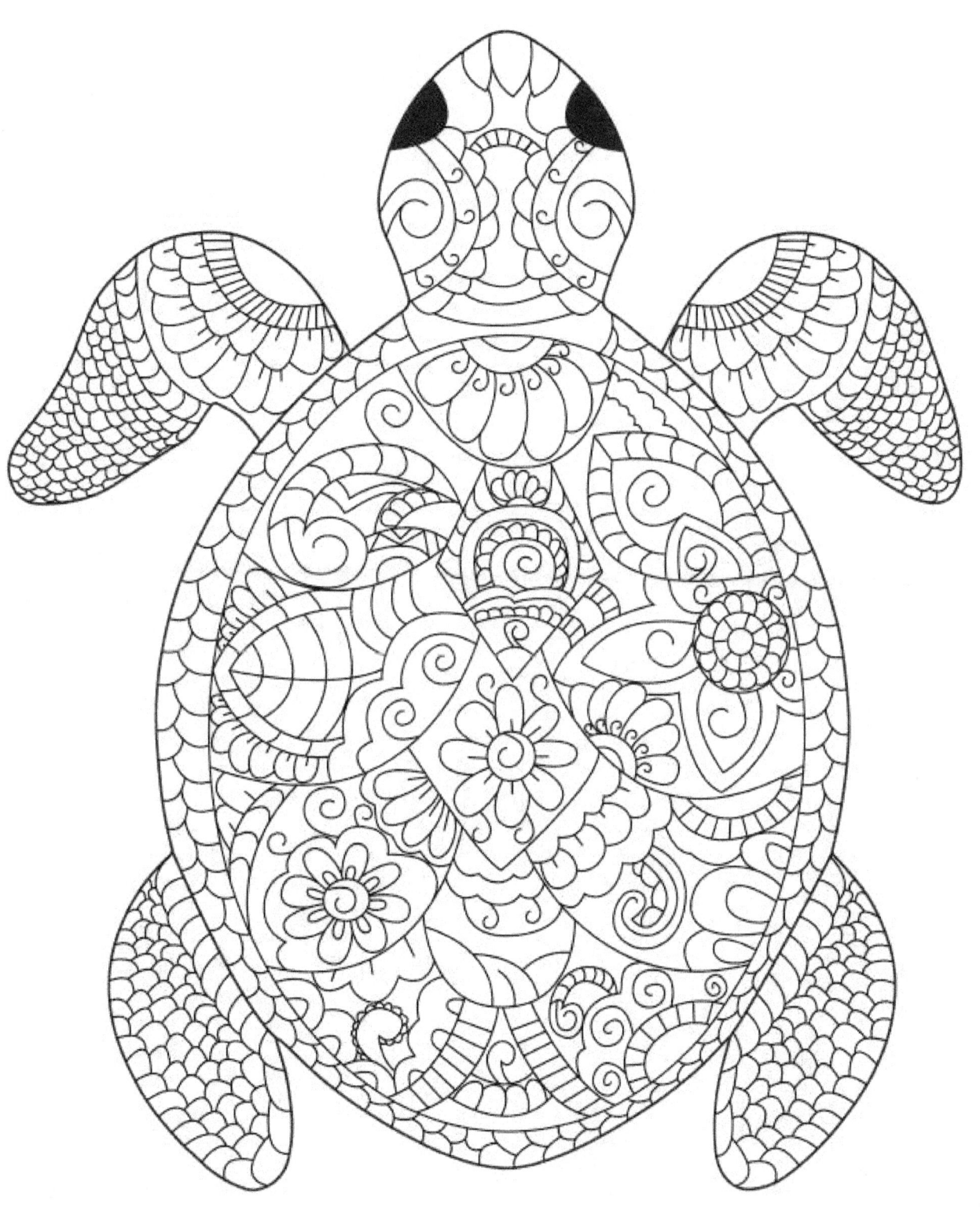

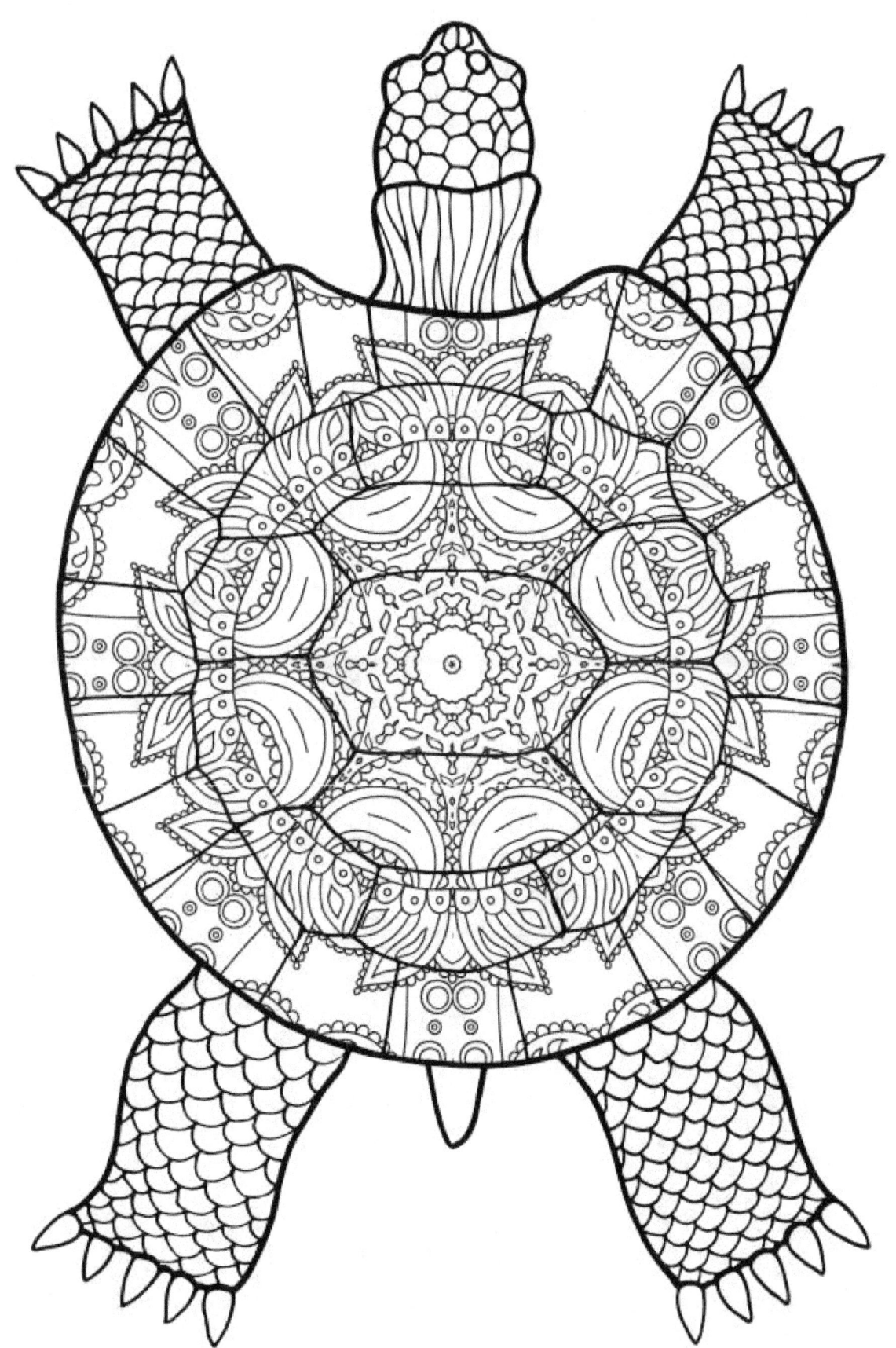

www.ingramcontent.com/pod-product-compliance
Lightning Source LLC
Chambersburg PA
CBHW081020170526
45158CB00010B/3111